T H E W T

D1203639

THE WAY WE SEE IT

Documentary Photography ~

by the Children of Charlotte

Text by Frye Gaillard & Rachel Gaillard

Book design by Mervil M. Paylor

The Light Factory in association with

Down Home Press

Front Cover Photo

Caneia Smithbey, 1995
Age 11

About the cover:
Ashley Byrd was
gesturing in excitement
toward a flock of geese.
As she took the picture,
Caneia decided to
focus on the face.

Back Cover Photo

Nancy Stanfield, 1995
Pictured: Jeremy
Edwards

The Light Factory
Photographic Arts Center
311 Arlington Avenue
PO Box 32815
Charlotte, NC 28232

Down Home Press
P.O. Box 4126
Asheboro, NC 27204

ISBN 1-878086-46-4

Library of Congress
95-069848

Printed in the United
States of America

In 1994-95, The Light Factory Photographic Arts Center taught photography to public school children in Charlotte, North Carolina, and others who come from deprived backgrounds. The classes, as well as this book and a series of exhibitions, were made possible by a grant from the Z. Smith Reynolds Foundation. Additional funding for the six-month project came from The Charlotte-Mecklenburg Arts & Science Council, First Union National Bank, Royal Insurance, Hoechst Celanese, Duke Engineering and Services, Inc., The Junior Women's Club, Ilford and A Day to Remember, with in-kind support from Quality Chrome, Eastman Kodak Company, Camera World and Ilford.

The Light Factory also worked with Dilworth Elementary, Eastway Middle, Hidden Valley Elementary, Sharon Elementary, Tryon Hills Elementary and Winterfield Elementary schools, along with the Johnston YMCA, Habitat for Humanity, Project Hope, The Phoenix Project, Fighting Back and Mecklenburg County Youth and Family Services.

The teachers were Nancy Pierce, Julie Simon, James Spence and Deborah Triplett. The text, written together by Frye Gaillard and Rachel Gaillard, is based on extensive interviews with the student-photographers. In all but a handful of cases, photograph titles were chosen by the photographers in consultation with the writers. The remaining titles were chosen by the writers. Special thanks for their energy, suggestions, feedback and support also go to Gail Boyd, Jeff Cravotta, Sachiko Day, Kevin Eakes, Nancy Gaillard, Darryl Jackson, Ginger Jantz, Jack King, Sarah Lacy, Marie Macdonald, Jodi Malone, Cara Matocha, Debbie Williams Myrick, Tracy Nelson, Steve Pepper, Jodi Poteat, Ashley Rankin, Amy Rogers, Tricia Sanford, Cici Stark, Robin Weeks, Ray Wilson and Dawn Yarber.

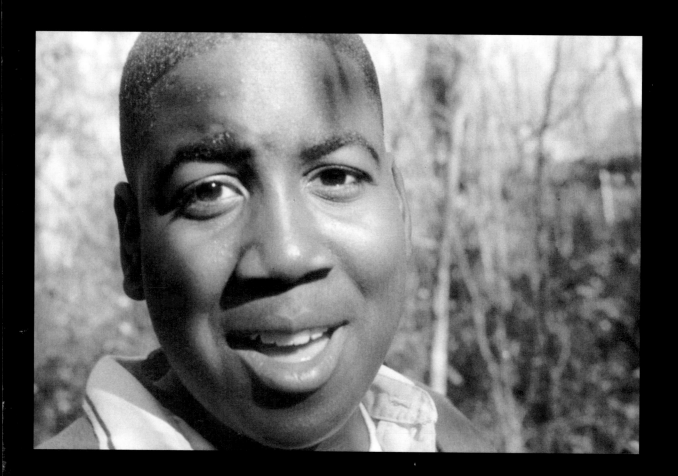

Michael Lowe, age 12, took this photograph of the face of his classmate, Rod Davis, in 1994.

Some of them have seen far more than they should — muggings, sexual assaults, drug deals, a friend shot down in a convenience store robbery. But the photographers whose work is collected here clearly have an eye for happiness and beauty. They are children, after all — most in elementary or junior high school — and despite the problems that sometimes surround them, their pictures, in general, are images of hope.

Their talents were encouraged by The Light Factory, a photographic arts center in Charlotte, North Carolina. Working with the Charlotte-Mecklenburg schools, the YMCA and other institutions concerned with children, the center offered intensive instruction to more than 200 young people, many of whom come from troubled communities. When they had mastered the basics, the students were asked to spend the next several months as documentary photographers of their own neighborhoods — their friends, their schools, their families, their lives.

Some of the best of their extraordinary work appears in this book — a testament not only to

their artistic talent, but to the ability of children to search out the beauty that adults can overlook.

Often, it's simply a matter of instinct. Mahada McDoom, whose photograph appears on page 78, was afraid her camera was out of focus when she tried to take a picture of two of her friends. She could see them only in faded silhouette, and yet somehow their moods came through. "I just decided to take it," she said, "to try something new."

At the same school, Sharon Elementary, Mahada's classmate, Michael Lowe, was "just messing around" on the nature trail when he saw his buddy, Rod Davis, walking just ahead. Rod was smiling and laughing, which was often the case, and his eyes were full of curiosity and life. Michael decided to try to get it on film, and the result appears on the opposite page of this book. To Michael, it is just a picture of his friend, and yet it is easy to see it as more — as the face of imagination and hope.

There is, of course, another side to the story, another side to the lives many children have known, and some of these photographers have caught that too.

Their images are often both subtle and strong. Lafayette Alexander photographed two doors on an inner city building, a barren tree limb in the corner of the frame (page 35). The effect was stark, yet somehow inviting — but for Lafayette the memory behind it was hard: "like what I saw out the window when I was locked up."

Anita Briggs has been in trouble also, but at the age of 15, her mistakes have made her think. Her photo of a police car seen through the window (page 23) reflects not only some scenes from her past, but a deepening ambition for her future as well. She wants to help change a dangerous world, maybe by becoming a police officer too.

Such ambitions are no surprise to Cara Matocha. As the art teacher at Eastway Middle School, she has seen the pressures under which children live — the exposure, too often, to trouble all around. And yet somehow they are able to make it — most of them at least — sometimes with the help of their parents and teachers, sometimes simply because of their strength.

"We have some incredible children," she says, "who have encountered some things that most adults couldn't fathom. Their talents can sometimes get covered up by anger or hurt or shyness and fear. We need to learn to listen to them more, and art is one of the ways we can do it."

That was the purpose of The Light Factory project; indeed, it is one of the missions of the center — to search out and celebrate the talents of children, some of whom come from difficult backgrounds, some of whom have been more lucky. The effect on the students remains to be seen, though many say photography has become their hobby, and perhaps in time could become even more.

Whatever happens, they have created an impressive body of work — a powerful portrait of one city's life, and the hope and the beauty that survived troubled times.

~ Frye Gaillard

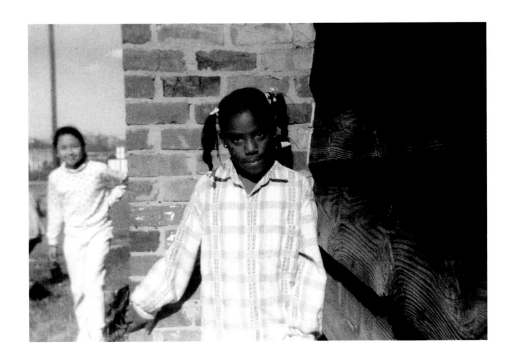

Basha Vang, age 10, took this portrait of his classmate, Zayona Hill, in 1995.

The skyline shimmers through the knee-high grass. Erica Brewton has seen it before, but never quite from this kind of angle. She is kneeling in the grass by the railroad tracks, somewhere in the inner city. The neighborhood around her is a little rundown, a part of Charlotte quite easily forgotten by those who inhabit the towers uptown. Erica likes bringing the whole thing together. For her, the grass from the vacant lot is as real as the promise of the skyscrapers looming in the distance. Her mother calls it a city growing up — with room for more growing before it is through.

Erica studies the picture and nods. She is trying to give it a name. "Downtown," she says, then changes her mind. She says the image is somehow more. After she thinks about it for awhile, she decides it's a picture of the city's very heart.

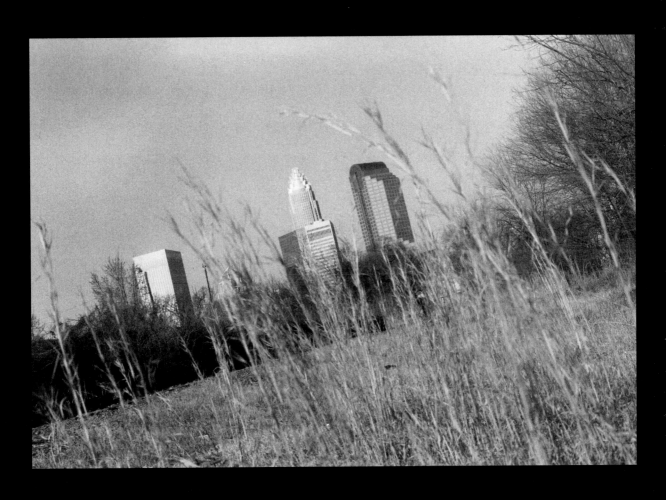

The Heart of the City ~ *Erica Brewton, 1995*

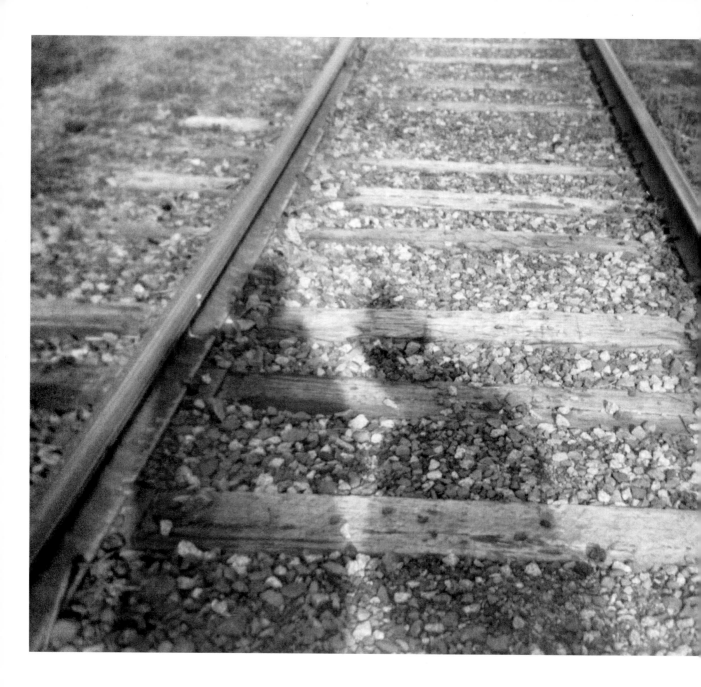

The track was quiet. No trains coming. Shaunté and her brother stood together in the stillness, the sun at their backs. There was something in the image that caught her attention — the parallel rails moving closer in the distance, the shadows frail and broken in the gravel. She wasn't quite sure that her camera would catch it, but she decided to try.

"I don't know why," she said. "I just did it. I just liked the way it looked."

Shadows on the Track ~ *Shaunté Lindsay, 1995*

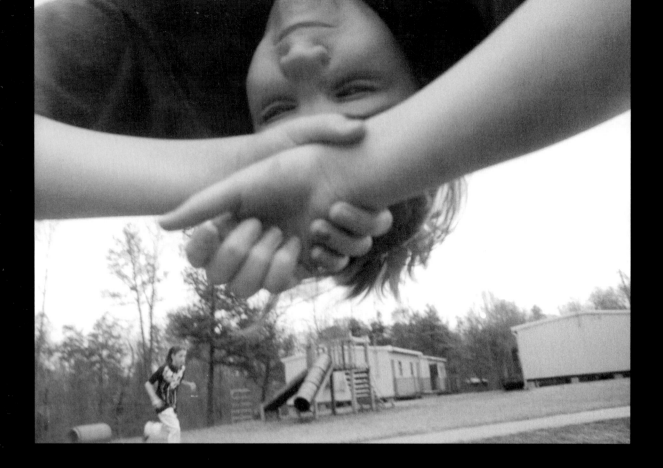

On a Rainy Day ~ *Savoeun Mom, 1995*

Savoeun Mom was experimenting when she took this picture. She was testing her limitations, tossing out conventions, trying to fill her frame without simply standing someone in the center.

Her friend on the bars was watching as the rain-clouds formed in the sky overhead. Her attention was completely distracted by now from the clicking of the camera on the ground just below.

She was caught in a world that was upside down.

*Emilia Repinetsky likes **altering her perspectives**.*

*After positioning her friend Nadirah atop the **jungle** gym, Emilia lay on her back on the ground and tried to decide the best angle. She liked the one that made the bars look like **diamonds**, while the whole jungle gym began to look like a **cage**. "I thought it was unique," she says. But her primary goal was more down-to-earth: to enhance the **effect** of what, in the end, is really just a picture of a kid having **fun**.*

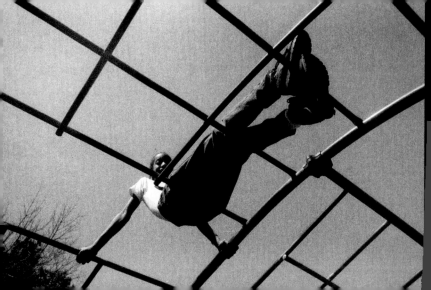

𝒯he basketball glides perfectly through the net. The swooshing sound is quickly drowned out by the cheers of his fans, as they turn their gaze toward the man who made the shot. This is Mike's dream.

He plays whenever the weather permits, sometimes in tournaments between apartment complexes (*The Cedars vs. The Pines*). Though the full-blown fantasy includes roaring crowds, a TV announcer and maybe someday the Goodyear blimp, a subtler reality would also suffice.

Mike would really like to make this shot in the presence of his pals.

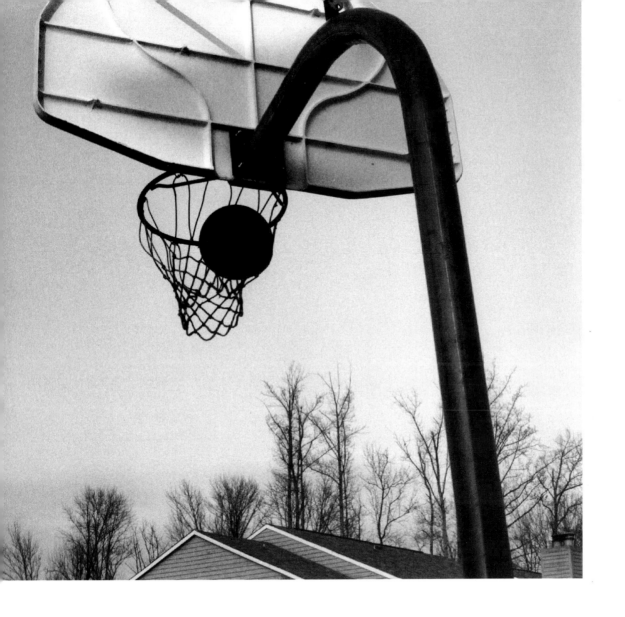

Hoop Dream ~ *Mike Goldberg, 1995*

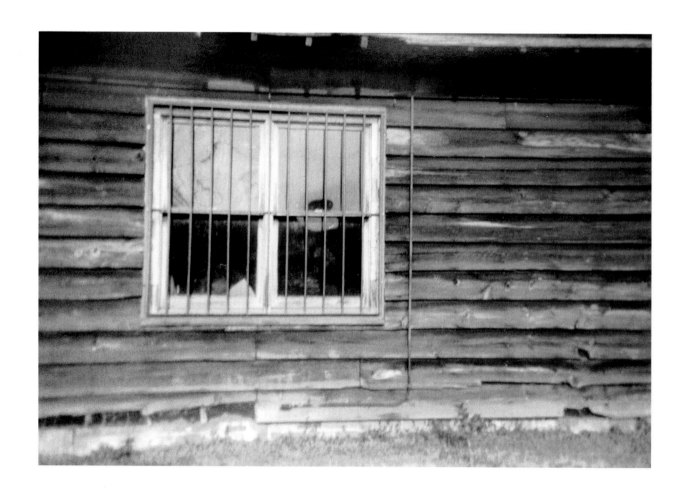

Trying Not to Shake ~ *Megan Leak, 1995*

She liked the house because it was old. The boards were weathered and beginning to rot, and she was intrigued by the bars and the white window frame. "I was nervous," Megan remembers. "But my dad's a photographer. He told me not to shake." In her mind, she measured the distance to the house, trying to get close enough to focus on the bars, but not too close. It was hard, she says, to get it just right, but in the end she was happy. Everything was there — the bars, the windows… the house in the heart of the city growing old.

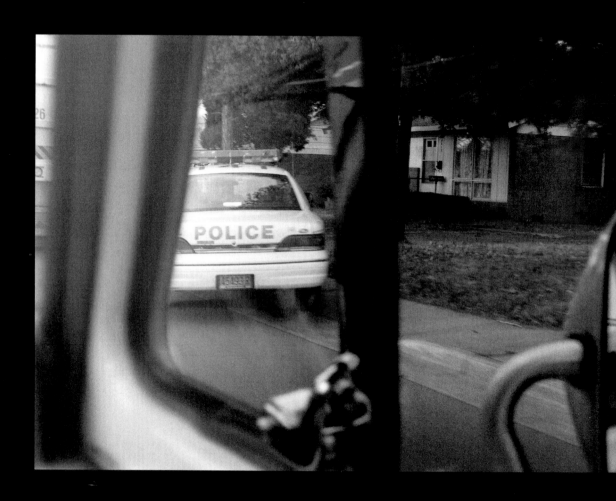

The Past and the Future ~ *Anita Briggs, 1995*

Anita has been in trouble before. "Been in lots of police cars," she says. It would be easy, then, to see this picture as a symbol of her past, and the mistakes she has made along the way. But that would not be looking deep enough.

After examining the frightening and bumpy path on which much of her life so far has been spent, Anita has changed. She says she's committed to helping other people. Even the police officers who have arrested her before are given her respect. "They care about people. That's why they became police officers."

Anita thinks the streets are too violent. She worries about a world in which children may not have the opportunity to grow up safely. She believes that in big cities a lot of people just don't live long enough. So she wants to turn her life around. She wants to go to college and use her story to help other people — to help change the world.

Now, she says, her ambition is clear. Someday she wants to be a police officer.

"*We were playing dead by the tracks.*

We wanted to pretend he was dead…

like somebody punched him."

Playing Dead ~ *Rogers Brown Jr., 1995*

Ed Cook is intrigued by the technical side of photography. (His favorite thing is the light-sensitive paper.) He had his camera ready one day in the park, and was examining the play of light on the bars that divided the picnic shelter from the steps leading up to it. He was, he says, "just having fun" when his friends trooped up the stairs. Ed snapped the picture. He likes the result — the dramatic contrast of light and dark, and especially the head of his friend, Taylor, framed neatly in the squares.

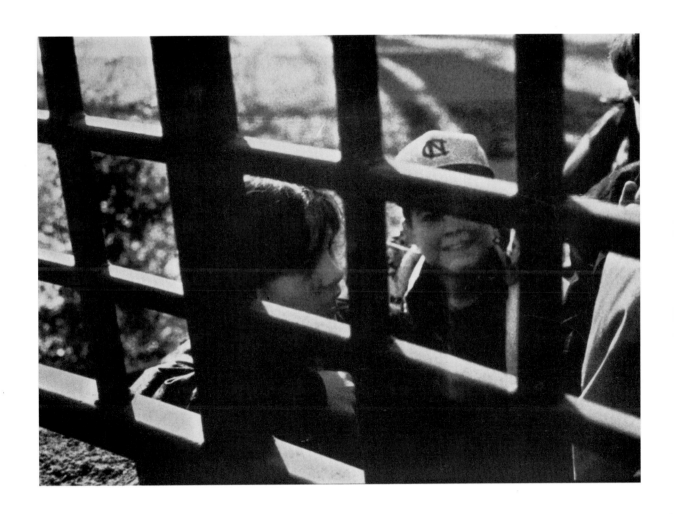

Lines and Faces ~ *Ed Cook, 1995*

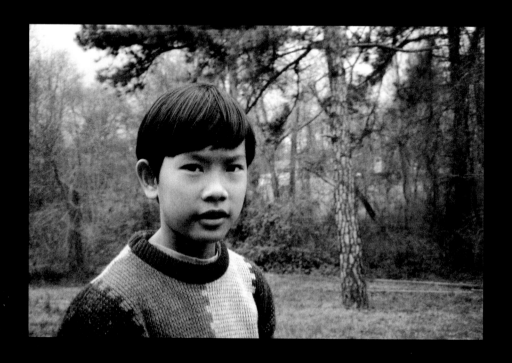

Just Walking By ~ *Jason Hailstock, 1995*

Jason Hailstock likes backgrounds, and initially that's what he was focusing on in this picture. He thought it was probably okay when his friend, Thinh Nguyen, walked through the frame. They're buddies, after all. Jason thinks Thinh is nice, and smart, and they play kickball together.

It was also fun not to have the picture posed. It provided a surprise in the darkroom, which is Jason's favorite part of the photographic process.

"I like it," he said. "He was just walking by."

Everybody noticed Larry's hair. He didn't always wear it that way, and the new dreadlocks sparked interest among his classmates — not only as a fashion statement but also as a prime photographic opportunity. Larry was eager to co-operate, lunging toward cameras and requesting portraits. Grace Mathis took one picture of just the top of his head (deviating from her normal routine of picturing animals) in order to capture what she saw as "a maze to go through."

Matt Farr just thought it looked neat. "I wanted him to lean down," he said when asked to describe the pose, "because he had those dots on his head." Larry, full of fun and full of spunk, was more than happy to oblige.

Larry's Hair ~ *Matt Farr, 1995*

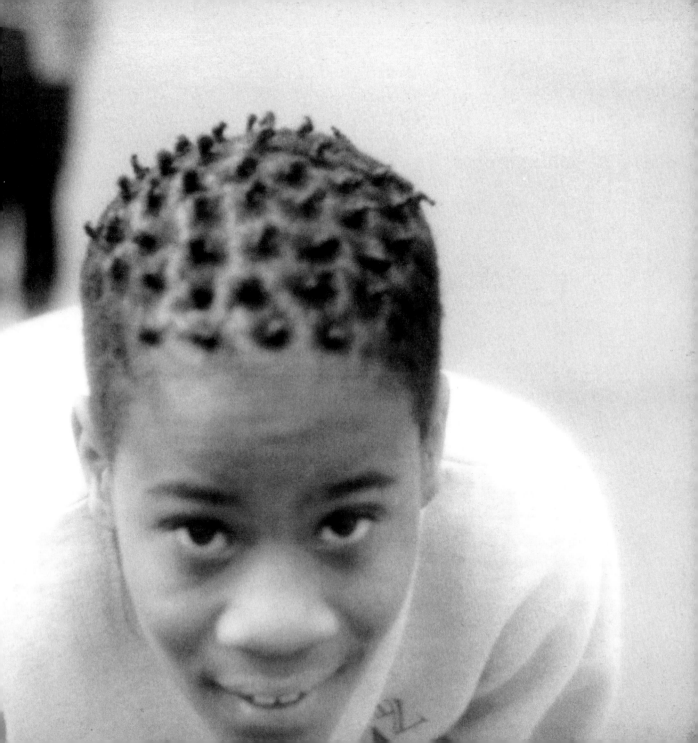

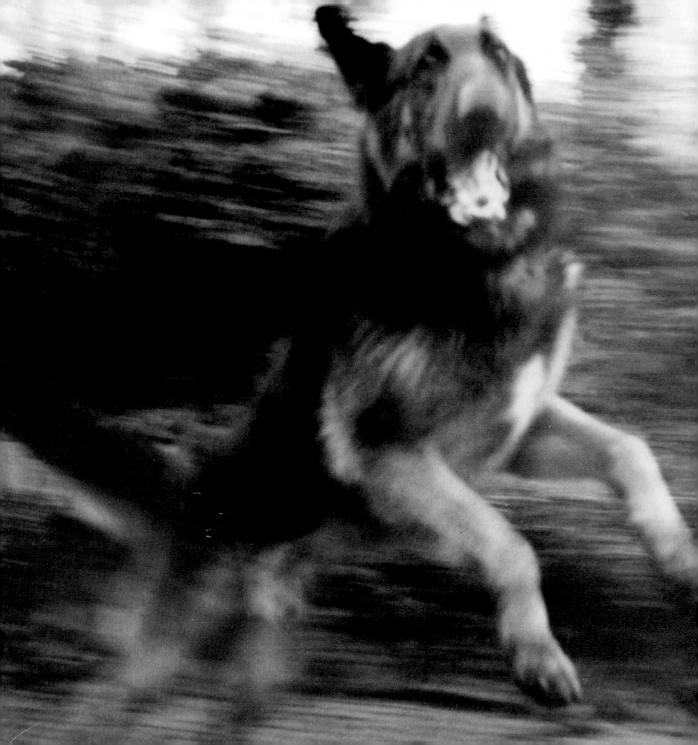

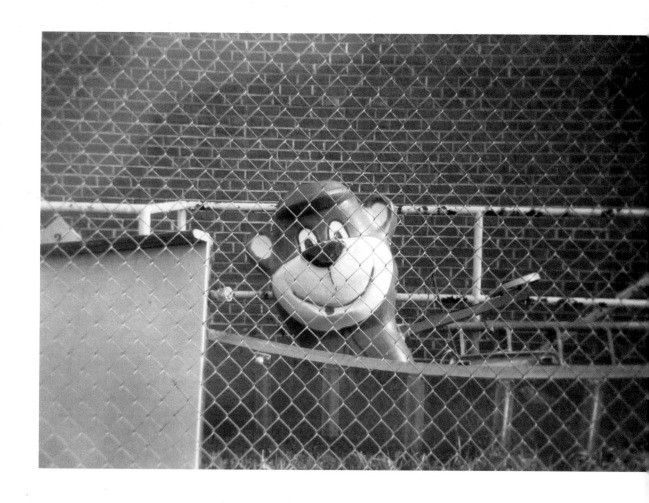

The Lonesome Toy ~ *Shaunté Lindsay, 1995*

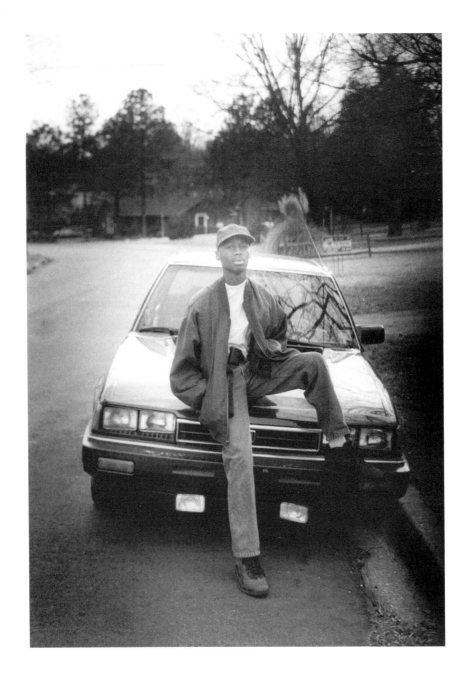

André's Car ~
William Spruill, 1995

William doesn't trust most adults, and he generally doesn't like teachers, and he made that clear when we were introduced. But then he began to talk about pictures.

William has dreams. He wants to be a doctor, or maybe to own his own business, like a grocery store in which he could employ his family and friends. That way, he could surround himself with the qualities he admires, the ones that he sees in his brother, André, and the ones that, inside, he aspires to himself: honesty, endurance, an even disposition.

He may be slipping through the cracks in the system, his talent sometimes obscured by his pride. His art teacher says he needs to be caught. William has gifts that some people miss. They are clear in the dignity of his pictures, however, and in the hopes he shares with the people who will listen.

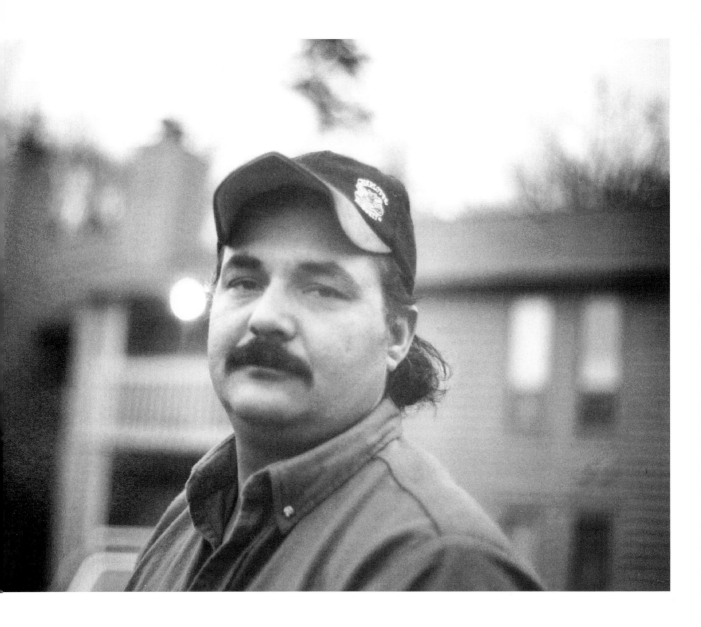

Role Model ~ *Mike Goldberg, 1995*

The eyes grab me. My gaze skirts to the rest of the photograph — the bent brim of the hat, the hazy windows of the apartments in the back, the shadowy suggestions of trees just over the roof. The mouth beneath the thick mustache does not smile, but tilts slightly in a vague conveyance of encouragement. I return to the eyes in their heavy-lidded gaze, and they seem to hold stories the meanings of which I cannot surmise. There is life behind the stare, although it is difficult to say whether what I am seeing is acceptance or resignation. The eyes are lined with a quiet peace and wisdom.

He is a Native American, and though he works in a power plant his love is making what his son calls "Indian stuff" — bowls, pots and pipes that celebrate his artistic and cultural heritage. He has been given an Indian name — Red Wolf — a fact which his son approaches with both awe and envy. Such names, explained Mike, are given in one of two ways: by the father at the child's birth, honoring a simultaneous occurrence in nature, or else as a reward for an act of courage. Mike does not yet have an Indian name, and it seems of particular importance to him that his father does.

Mike says his father "can be happy, but he'll look sad." I study the picture, concluding once more that experience weighs heavily in the eyes. Yet the hope in the moment is a tender thing as the man possessed of an Indian name turns his glance to the camera of a son still waiting for his.

~Rachel Gaillard

Intentional Beauty

The sun was shining on the North Charlotte mural where Lafayette's photography class was walking. In fact, it was the light on the building that attracted him at first, that made him walk closer and investigate. The rose with its shadowy thorns looked like something to be given in a time of great sadness. And yet it was surrounded by an aura of painted brightness, and the sunlight bathing it was so intense.

Lafayette took the picture, and later he tried to give it a name. Was it grief? Was it grace? Was it somehow both — a piece of art both happy and sad, depending in the end on his own frame of mind? In any case, he was glad for this touch of intentional beauty on a building that was otherwise covered in graffiti.

"He's a mean one,"
Gabriel explained.
It was the first picture
he took when he brought
his camera home from
class. The dog appeared
as if out of nowhere,
snarling, lunging, pro-
tecting his turf. Gabriel
fell backwards getting
out of the way, but he
remembered to snap
the shutter as he went.
Later, he shrugged.
The dog, he said, was
only doing his job.

Fear ~ *Gabriel Lathan, 1995*

"The first thing I noticed was the colors.

The walls were real red, the doors were white.

Then I knew it reminded me of something.

You really want to know?

It's like what I saw out the window when I was locked up."

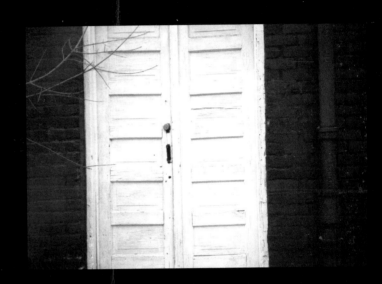

Ready to Leave ~ *Lafayette Alexander, 1995*

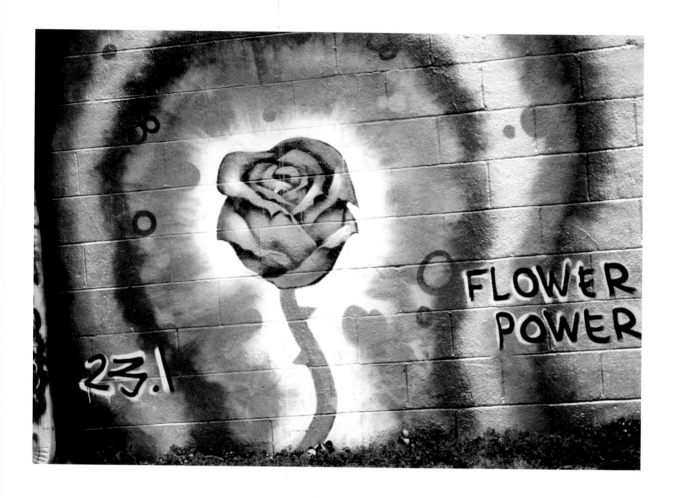

Grief and Grace ~ *Lafayette Alexander, 1995*

The
bear
looked
silly

and
lonesome
all at
once,

cut
off
by
the
fence.

Somehow,
it
was a
picture

she
just
had
to
take.

Glenda Roman is quiet. She doesn't have much to say to adults — certainly not those she barely knows. She has a bright face and an apologetic smile, but she volunteers little when asked about her life. Her photograph, however, tells a different story — a story of friendship and relaxation, of fun and community and the silliness that sometimes ties friends together. These are the bonds she shares with her peers, a reprieve from the caution of a grown-up world.

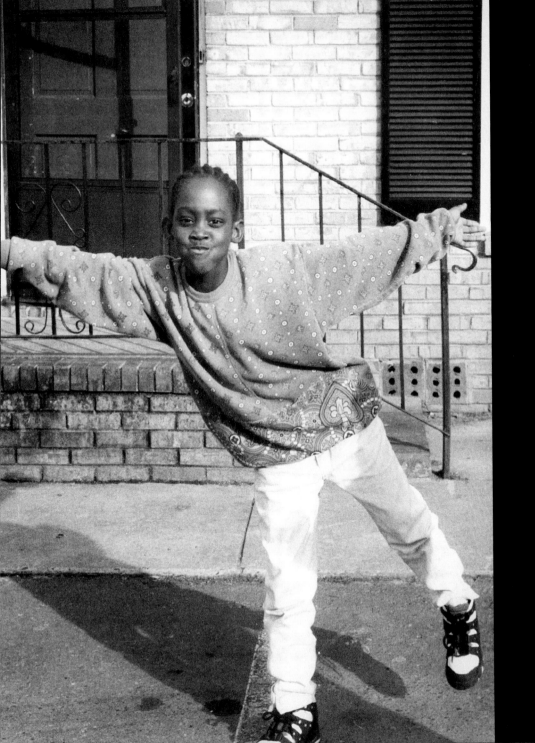

A Friendly Face ~
Glenda Roman, 1995

Latoya was passing by the basketball game, camera in hand, when one of her classmates, Tryell Doctor, called out for her to take his picture. "I told him to move, not stand there," she says. Tryell began to dance the Butterfly, while the basketball game continued behind him. Latoya snapped the picture, and then moved on, not really thinking about it after that. She had her mind on portraits of trees. "I like to learn about nature," she says. But later, when she saw the picture of Tryell, Latoya had to laugh. The expression on his face was funny, and the basketball players behind him were suspended in the air — "like they were posing," Latoya decided. "You wonder how long they can just hang there."

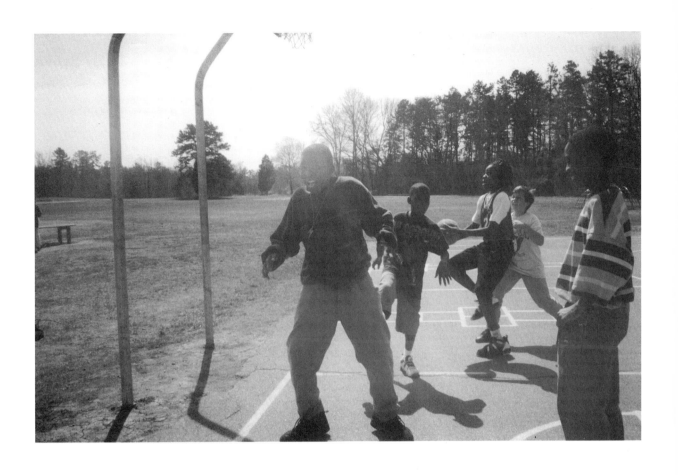

Posing in the Air ~ *Latoya Green, 1995*

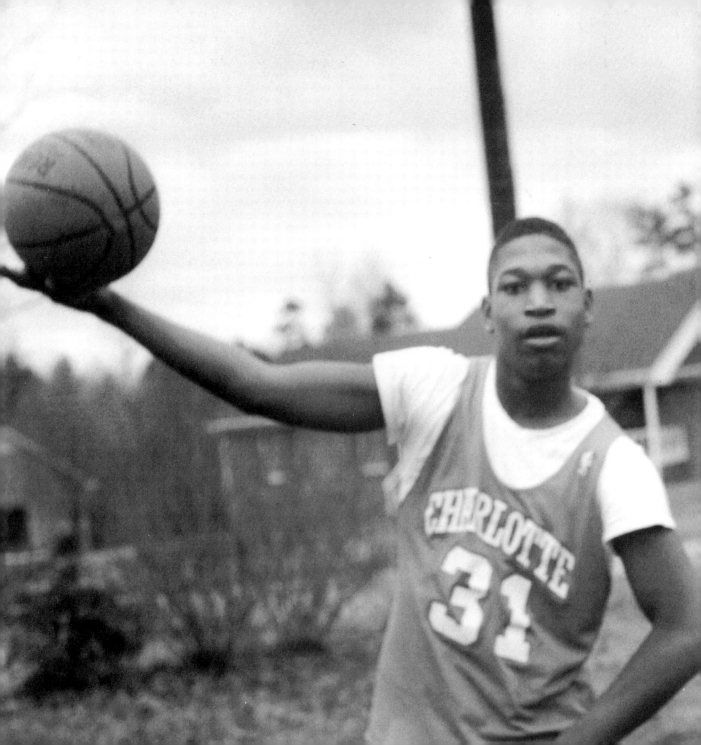

Chris wants fame. And money. He cares a lot about his image, but he's guarded, too. He has made some mistakes, and he and his friend, Maurice, both know the trouble that lives in the streets. They play basketball whenever they can, partly for fun and partly to dazzle the people who are watching. They don't talk much when strangers are around, but they want it understood that **they are good** with a camera and good on the court — and it's way past time for somebody to **notice.**

Jordan ~ *Chris Oxendine, 1995*

Doberman? ~ *Megan Fair, 1994*

egan was surprised that a doberman pinscher linked by a chain to the hand of its owner turned out to be so friendly, and as long as everybody was petting it when she had her camera right there, she thought she'd better document it. Originally she wanted the dog to face her, but it wouldn't cooperate. Megan had learned about using different perspectives in her photography class, so she hunted for a way to incorporate the knowledge while her friends kept the dog busy. She liked the clean, bold lines of the end result, and she liked the message too.

She liked those children's hands on the placid head of what she had always assumed to be a vicious beast.

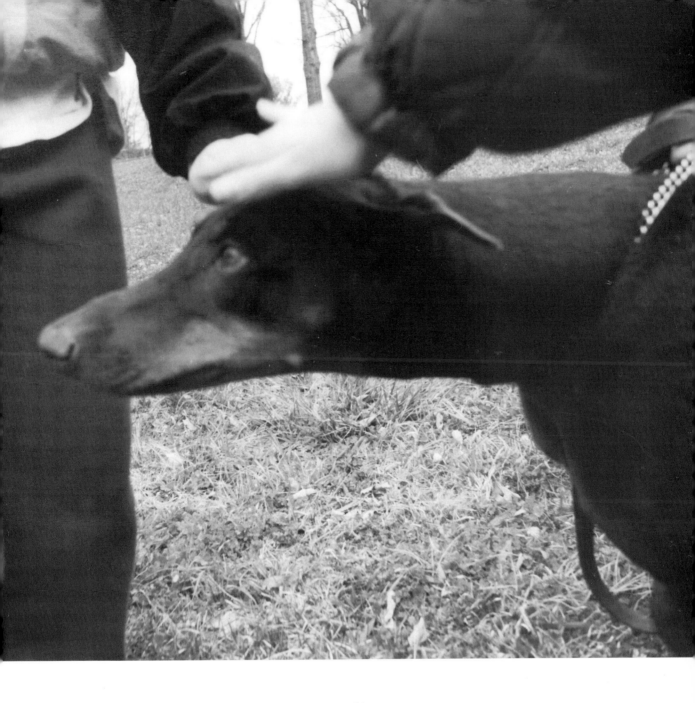

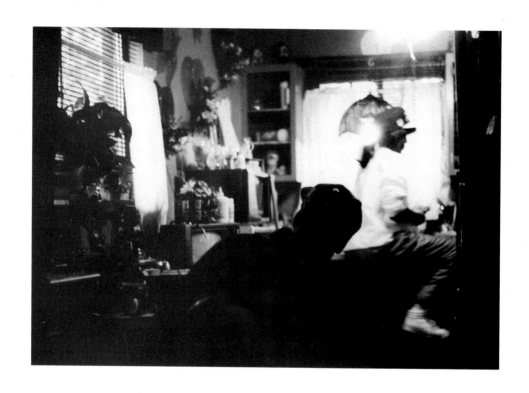

An Average Day ~ *Brian McIlwain, 1995*

*I*t's "an average day" at Brian McIlwain's house. Plates and glasses are stacked in their usual places on the microwave and in the open cabinets. The fans his mother purchased at Big Lots decorate the left wall. His parents are in the kitchen before dinnertime, father sitting and mother standing with her left foot supported by the rung of a stool. But there is drama and intrigue in Brian's photograph. This is a busy place, light and shadow harmonizing and arguing, the family together but also separate, the kitchen cluttered but with everything in its place. It's the ambiguity of everyday life — the drama of the average, captured through the keenness of a teenager's eye.

Richard doesn't know Basha Vang very well. Basha is two years younger and shy, and they seldom get out on the playground together. But when Richard saw Basha sitting by himself, he was struck by the pose. "It looked to me like he was sitting down thinking." He remembered the statue from one of his classes — the one of a man with his chin on his fist — and he thought the pose was a little bit similar. The hands were different, but the mood was the same.

Richard says he likes taking pictures of people. They are his favorite subjects in a hobby he's decided he'll probably pursue. He thought about giving it up for awhile. It was taking time from his studies, where he wants to do well, but one of his counselors said he had a lot of talent and encouraged him strongly to try to stick with it.

"He told me, 'hang in there, and something good will happen.'" Richard smiled, remembering those words. He thinks it's possible that his counselor is right.

Thinking ~ *Richard Baker, 1995*

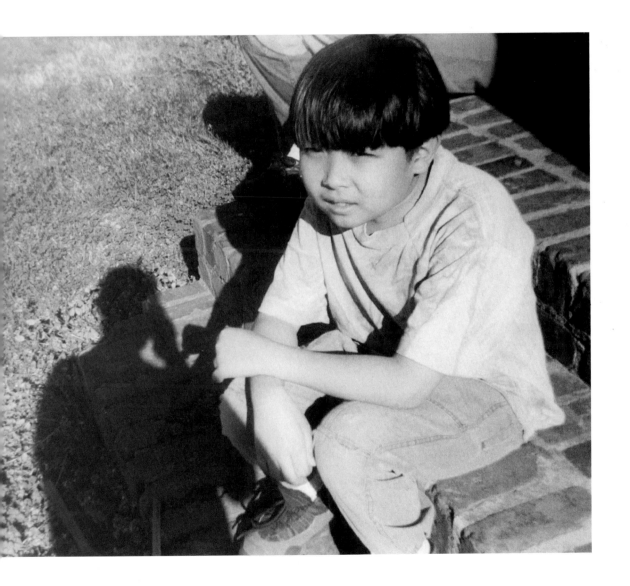

It is early evening and The Fresh Prince is on.

Jeremy decides to take its picture. He knows for many families the TV is entertainer, baby-sitter, informer — and the list keeps growing.

Jeremy says he tries to be different. He doesn't watch a lot of television. He'd rather ride his bike or play basketball with his friend up the street.

But he understands the power he has caught in his lens — in an image more stark than he even intended.

TV ~ *Jeremy Dillinger, 1995*

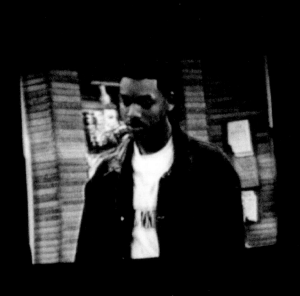

It was a cold day in Latta Park, and the kids were all moving around to stay warm. Kathryn watched as one of her classmates

pumped the swing, and she thought about what her photography teacher had said. Be creative, he had told her, be unconventional.

Think about perspective. Kathryn studied her friend moving through the chill and decided to try to get it on film. The developed print was

exactly what she wanted — a riveting mixture of shadows and blur and clean, hard lines that somehow captured the mood of the day.

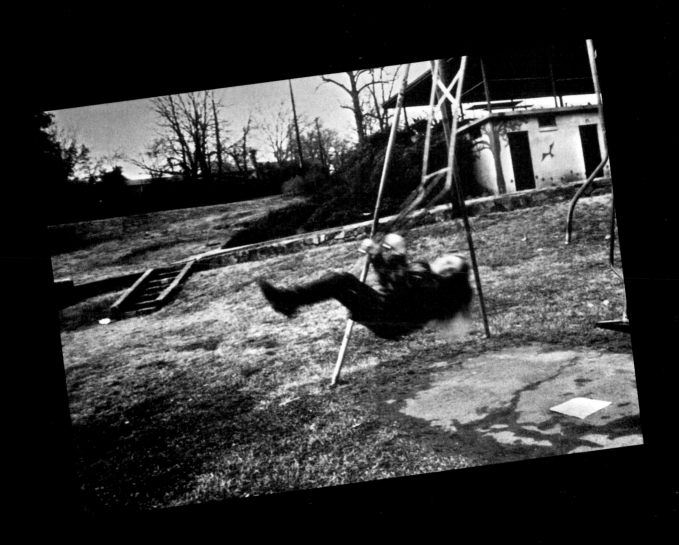

The Swing ~ *Kathryn True, 1995*

*A*drienne Caldwell really wanted to take a picture of the duck pond. The hole in the fence which had once pro-vided access had been unexpectedly mended. She pressed close with her camera, trying not to let too much of the chain link show, hoping the peaceful feeling of the pond could still be captured.

She knows another pond that she likes even better. It's nestled not far from where she lives — a place to feed the ducks and walk on the rocks, unencumbered by fences to keep her away.

A View Through the Fence ~
Adrienne Caldwell, 1995

Away ~ *Brian McIlwain, 1995*

Brian passes
these tracks
every day,
but the trestle
is anything
but routine.
It makes

him dream.
He thinks
about places
he'd like to see.
Orlando,
maybe.
He wants
to visit the

Nickelodeon
Studios,
and cheer for
the Magic
in the NBA.
He dreams
of heroes,
Shaquille O'Neal
and

Penny Hardaway,
and imagines
the day
when
he'll finally
get away
to the places
he's only
pictured
in his mind.

"I just like taking pictures," he said.

For Justin, the first photography class went badly. Not a single picture turned out. The next time he headed for the woods. Justin always had a thing about trees. They were good for climbing, or maybe as a place to sit and read, and with the branches still bare, he liked the way the sun came through, making shadows and silhouettes against the sky. He could see the shapes as he peered through the lens. There was something spooky about them, he thought, but peaceful too, and he wanted to capture all that with his camera.

In the end the image that appeared on paper was the same as the one that he carried in his head. He was happy about that, pleased with the mastery of his new form of art.

"I just like taking pictures," he said.

This was a picture that didn't turn out. Taylor was hugging a dog in the park, and Jonathan was trying, as he focused his camera, to get both the dog and the boy in the shot. He says he was trying to "fill up the whole frame," but he got too close and the animal was lost. Jonathan shrugged when he saw the result. "It's still pretty good," he decided, for it's the nature of art sometimes to surprise — and the nature of a kid to be open to it.

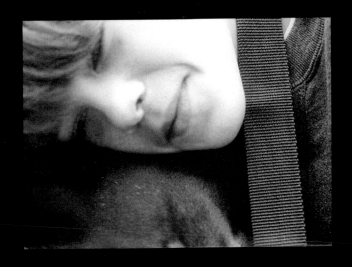

Filling the Frame ~
Jonathan Lovelett, 1994

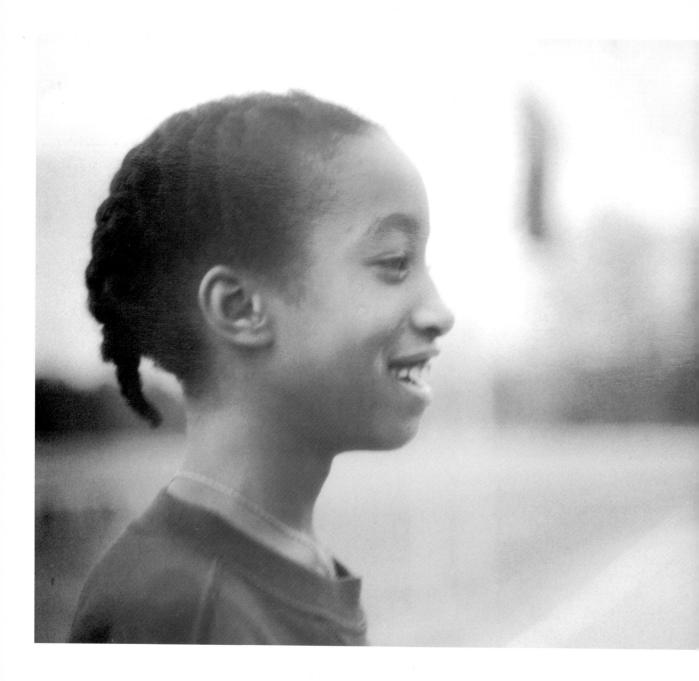

It's good to have a friend like Nadirah El-Amin. Emilia has thought about it a lot. They spent time together in photography class, and Nadirah was always friendly and fun — laughing, teasing, quick with a joke. But there was something else that was just as important. "She has good ideas," said Emilia.

When the class was over and she had one shot left on her roll of film, Emilia aimed once again at Nadirah. She was happy when she saw the picture that resulted. Everything, she said, was there in the face.

Nadirah ~ *Emilia Repinetsky, 1995*

Friends ~ *Gabriel Lathan, 1995*

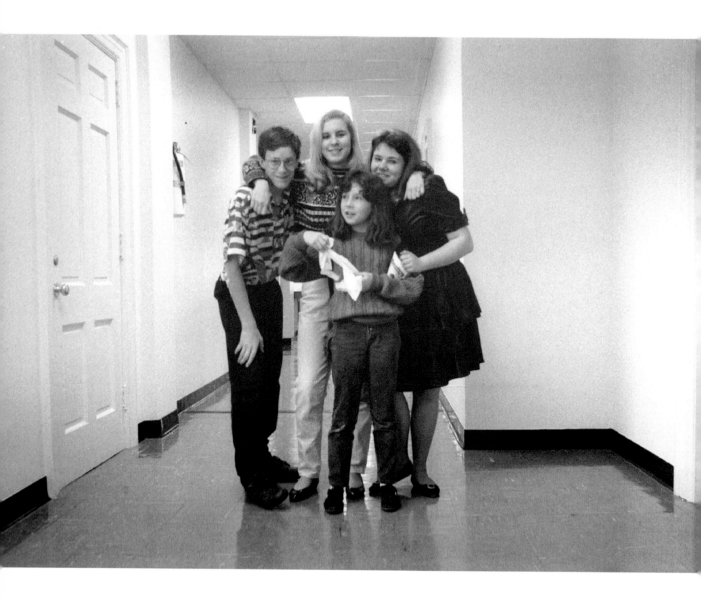

Gabriel Lathan moved recently, and although he makes friends easily he found the transition hard. His school is different. His room at home is different. He doesn't have a history here. But all this is tempered by the ties he keeps with a youth group back in his old hometown. It's a reasonable drive to the church on a Sunday, and on a recent visit Gabriel took his camera. He set the self-timer in order to get a picture of himself with his friends.

He stands a few inches apart from the girls, leaning in. It's an image somehow awkward and free, as he celebrates the bonds with his old friends at home.

Gregory at first was just fiddling with the shapes. During a class at the Johnston YMCA, he had found a box of dominoes in the closet and decided to line them up and take a picture. He worked hard at the design, a twisting row that threw dark shadows on a white background. It matched the dominoes, he decided, a subtle interplay of black and white.

After a while he started to think about people, and he decided to name his picture "integration." The symbolism of the title seemed nice, but the shadows were the thing that held his attention. He wanted more. There were endless possibilities in a row of dominoes, twists and turns and the rush that comes when the first one is tipped. But the teacher told Greg to hurry up with his picture, and in a way it was probably a good thing that she did. He might have thought about it all day, and missed the satisfaction that comes when your camera gets hold of the perfect photograph.

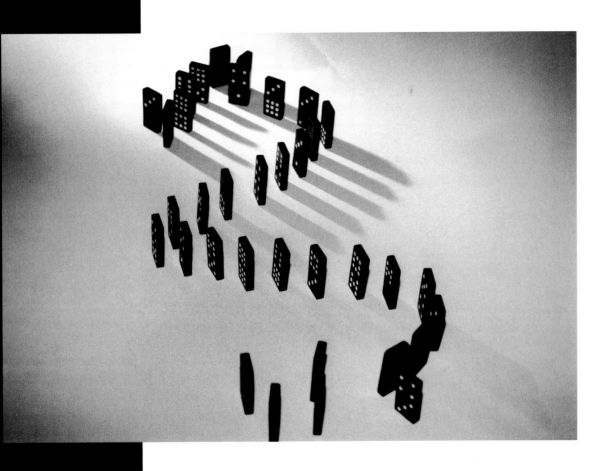

Integration ~ *Gregory Brewton, 1994*

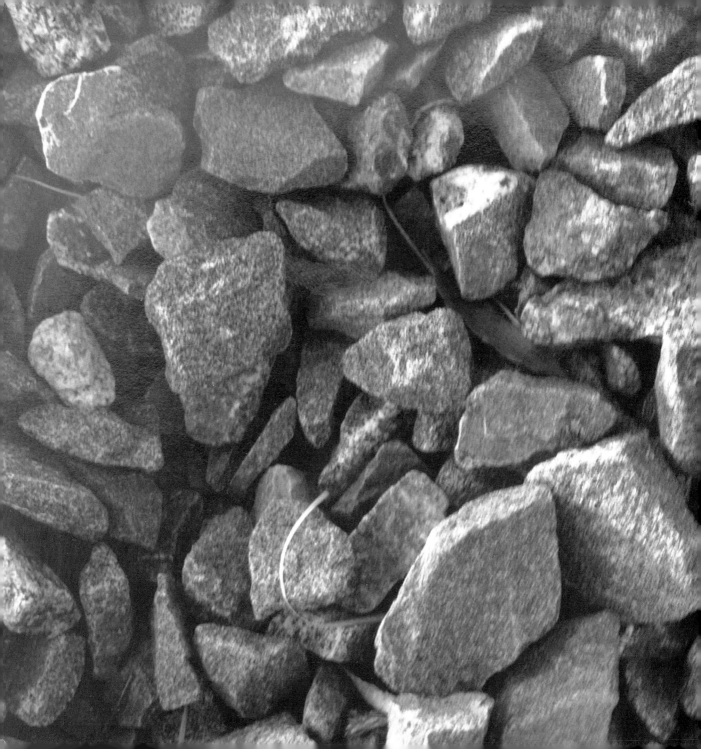

*A*ltereek Brewton was walking along the railroad track, gazing at the stones that lay between the rails. **He had his camera, and he was looking for a picture that no one would take.** "I like to be different," he says. He had experimented with his photographs before, like taking droplets of water on a leaf when it rained. He saw the shapes that were made by the rocks, and he aimed his camera at a close-up range.

"I like the abstractness of it," he decided. There was something hypnotic about the pattern — peaceful, he thought — though he knew that was only his own interpretation.

But that was the thing about an abstract image. The harder and longer you studied the shapes, the more your imagination could roam.

"You look at it," he said, "and you start to think. You keep looking at it, and that's what happens: You can just think."

Rocky Road ~
Altereek Brewton, 1995

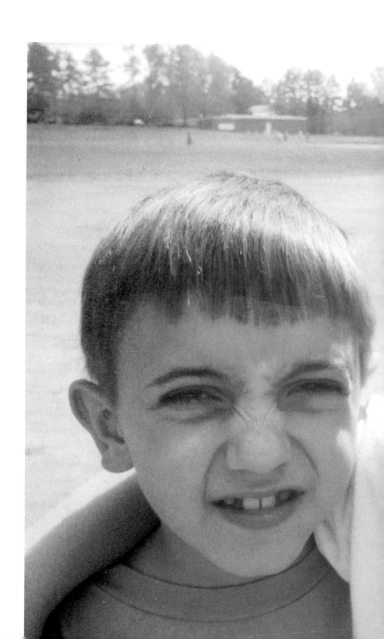

Emilia sounds like many big sisters when she talks about her little brother, Anatoly (left). "Makes me crazy!" she grumbles, but she says it fondly. She likes to watch him play with his friends, especially Adam Joyner. She had her camera one day when they were together, and she made them pose on the school playground. "I thought it would be neat," she says, "since they were best friends.

It's like a memory."

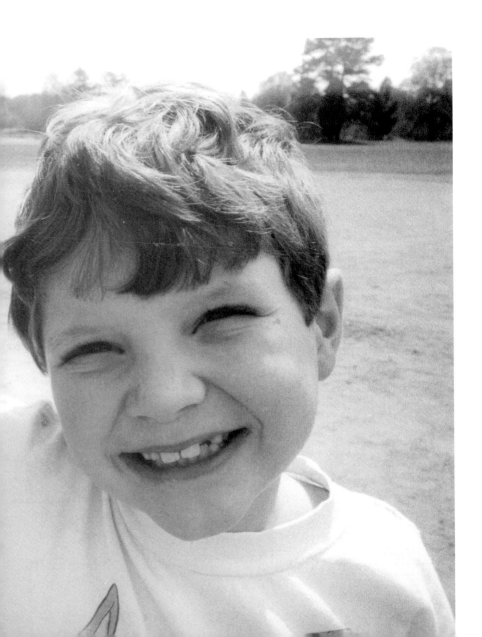

Best Friends ~
Emilia Repinetsky, 1995

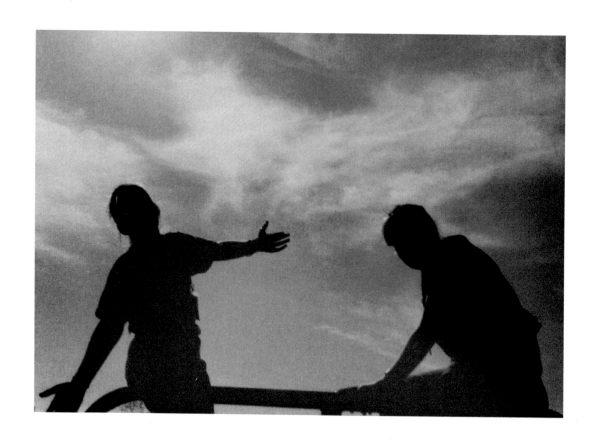

Silhouette ~ *Mahada McDoom, 1994*

Photographers

Lafayette Alexander,
PP. 35, 36

Richard Baker,
P. 55

Altereek Brewton,
P. 74

Erica Brewton,
PP. 11, 80

Gregory Brewton,
P. 73

Anita Briggs,
P. 22

Rogers Brown Jr.,
P. 24

Adrienne Caldwell,
P. 61

Ed Cook,
P. 27

Jeremy Dillinger,
P. 57

Megan Fair,
P. 51

Matt Farr,
P. 31

Mike Goldberg,
PP. 19, 39

Latoya Green,
P. 47

Jason Hailstock,
P. 28

Gabriel Lathan,
PP. 32, 70

Megan Leak,
P. 20

Shaunté Lindsay,
PP. 12, 42

Jonathan Lovelett,
P. 67

Michael Lowe,
P. 6

Mahada McDoom,
P. 78

Brian McIlwain,
PP. 52, 62

Savoeun Mom,
P. 14

Chris Oxendine,
P. 48

Emilia Repinetsky,
PP. 17, 68, 76

Glenda Roman,
P. 45

Caneia Smithbey,
COVER

William Spruill,
P. 41

Kathryn True,
P. 59

Basha Vang,
P. 9

Justin Young,
P. 65

Project Coordinator

Nancy Stanfield

Photography Teachers

Nancy Pierce

Julie Simon

James Spence

Deborah Triplett

Photo Editors

Linda Foard

Frye Gaillard

Rachel Gaillard

Monicah McGee

Alice Sebrell

Nancy Stanfield

Text Authors

Frye Gaillard

Rachel Gaillard

Book & Cover Design

Mervil M. Paylor

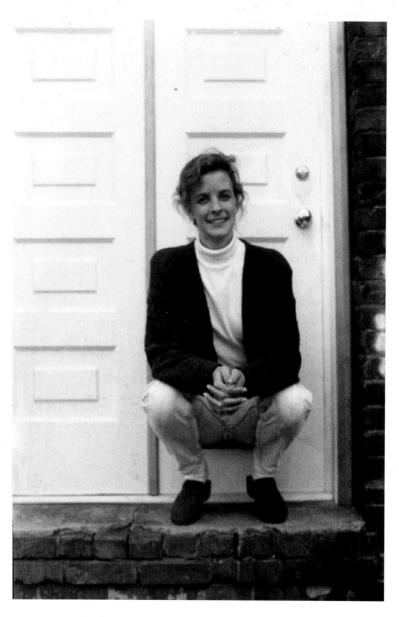

Erica Brewton, age 10, took this portrait of Project Coordinator Nancy Stanfield in 1995.